Camille Pissarro
and his family

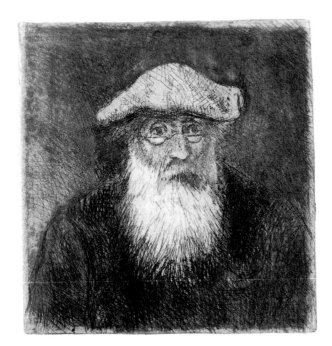

Camille Pissarro

Self-portrait
Etching, *c.*1890
18.5 × 17.7cm, D 90

Ashmolean handbooks

Camille Pissarro and his family

The Pissarro Collection
in the Ashmolean Museum

Anne Thorold and Kristen Erickson

Ashmolean Museum Oxford
1993

Funds bequeathed to the Department of Western Art by
Mary Freeman have made publication of this book possible.

ISBN 1 85444 031 4 (paperback)
ISBN 1 85444 032 2 (papercased)

Titles in this series include:
Drawings by Michelangelo and Raphael
Ruskin's drawings
Oxford and the Pre-Raphaelites
Worcester porcelain
Italian maiolica
Islamic ceramics

British Library Cataloguing in Publication Data
Thorold, Anne
 Camille Pissarro and his family
 I. Title
 759.4

Cover illustration: Camille Pissarro, *Quai au Havre*, plate 23

Designed by Cole design unit, Reading
Set in Versailles by Meridian Phototypesetting Limited
Colour separations prepared in Hong Kong by Imago Publishing Ltd
Printed and bound in Great Britain by Jolly & Barber Limited,
Rugby

Introduction

The Pissarro Collection was presented to the Ashmolean Museum by Lucien Pissarro's widow Esther and their daughter Orovida commencing in 1950. Lucien Pissarro had lived in England from 1891 prior to his marriage: but the accumulation of the archival part of the Collection, with the exception of family letters which date from 1883, is only thoroughly complete from 1900, by which time Lucien was living in London and was shortly to move to The Brook, Chiswick, which remained his home for the rest of his life. His own drawings, sketchbooks and collection survived the early moves and exist from 1883. The intention was that this should be a family gift comprised of original works, letters and printed documents relating not only to Camille Pissarro but also to his five artist sons. The selection was made from Lucien Pissarro's own collection after his death by the art historian Miss Luli Huda, whose initial listing references appear on a number of the original works. The availability of the entire collection to the public was finally realised in 1990 through a generous grant from the Getty Trust, although that part comprising the work and correspondence of Camille Pissarro had been accessible previously and is fully published[1]. By 1952 the main transfer to the Ashmolean Museum was completed. Although Lucien Pissarro had periods of financial difficulty throughout his life, he had nevertheless been able to retain a major part of his share of his father's works, inherited from the family division in 1904, from subsequent distributions made by Madame Julie Pissarro, wife of Camille, and also that made of her own estate at her death in 1926. Under English law the division of Lucien's estate

[1] In Pissarro/Venturi (P&V), Delteil (D), Brettell and Lloyd (B&L) and Janine Bailly-Herzberg (JBH) – Abbreviations list on p.9

at his death did not entail its similar fragmentation, and although Orovida Pissarro did sell a number of the works she inherited from Camille, she continued donations, chiefly of her father's and her own work and correspondence, until her death in 1968. The collection has been considerably augmented in subsequent years with the gifts of works and material initially retained by Esther and Orovida Pissarro, from their nephews and executors, David and John Bensusan-Butt. Both have also added material from their own collections, and other benefactors too have presented both works and funds.

That Camille Pissarro kept all his letters is clear from papers in this archive, although many were destroyed after his death. Lucien and Orovida did the same, and their papers (some 65,000 sheets) although sifted prior to their donation, cover every aspect of their lives down even to household bills, and constitute a major source of material on the period, both manuscript and printed. The re-dating of certain works has been possible on the basis of currently available documentation. Space here has not allowed for Camille Pissarro's prints of Rouen or caricatural drawings to be represented: they are fully documented in Delteil and in the Brettell/Lloyd catalogue (B&L).

Abbreviations	JBH	Bailly-Herzberg, J.
	B&L	Brettell, R. & Lloyd, C.
	D	Delteil, Loys
	P&V	Pissarro, L.-R. & Venturi, L.
	AT	Thorold, A.

1 Camille Pissarro
Landscape with female figures washing clothes in a river c.1854

Camille Pissarro was born in St. Thomas, Danish West Indies, where his Jewish family were prosperous merchants from France. He went to school in Passy (near Paris) from 1842–47, before starting work in the family business back on St. Thomas. The earliest drawings in this collection – of which there are over four hundred in all – date from 1852. In November 1852 Camille Pissarro left for Venezuela with the landscape painter Fritz Melbye and remained there for two and a half years. 'I could not stand it there, without much thought I left everything and fled to Caracas in order to break the chain which tied me to bourgeois life'[1]. This pencil drawing shows Caracas in the middle distance. The theme is one that was to reappear throughout Camille Pissarro's oeuvre – peasant figures working in a landscape. The simplicity of the rendering of a complicated subject, and intense attention to detail, were also to be lasting characteristics. 'Pissarro the draughtsman was born in Venezuela: Pissarro the painter in France'[2]. A variable and broken outline and the use of diagonal hatching are hallmarks of his early drawings, of which there are thirty-four in the Ashmolean – several, as here, with drawings recto and verso. Camille Pissarro was short of money in Venezuela, which may also account for the lack of known oil paintings for those years.

After returning to St. Thomas in 1854–5 for a few months, Camille left in September 1855 to live in France for the rest of his life. Already the classical landscape had no place in his vision, and it was to the new work of Corot and the Barbizon school that he turned first, upon arrival in Paris. But already, too, it is his *sensation*, translatable as his quickening of emotion in front of nature and his mental response both to the essence of the scene and to its harmonised representation, which was to be his touchstone.

Pencil 30 × 36cm, B&L 15 recto
Pissarro gift 1952

[1] 1878 JBH I p. 123
[2] J. Pissarro *Pissarro*, 1993 (forthcoming)

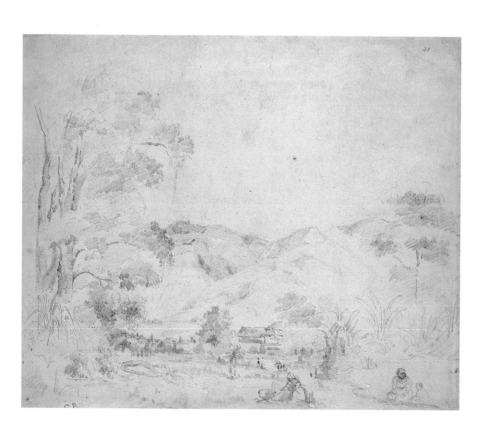

2 Camille Pissarro
Madame Pissarro cousant 1860 [Madame Pissarro sewing]

Julie Vellay (1839-1926) met Camille Pissarro when she went to Paris to find work and had become cook's helper in his parent's home in Passy, where they had moved in 1855 from St. Thomas. His parents refused permission for Camille Pissarro to marry Julie when she became pregnant late in 1860 – she was neither Jewish nor educated. They later married in England in 1871 in a registry office. Camille Pissarro's reaction to his bourgeois upbringing, begun in St. Thomas, was deepened by his family's rejection of Julie – although he remained close to them and indeed financially dependent upon them. He refused to accept the social and religious conventions of Parisian Second Empire society, whose values and restrictive cultural climate he found impoverished: and by extension, the didactic regulations of the official art world then in effect.

This small oil portrait, one of two from 1860, is intimately and lovingly painted in Camille Pissarro's early style, under the influence of Corot. He did few portraits, and most are of his family. Of Julie Pissarro there are six oils and one pastel in the Pissarro/Venturi *catalogue raisonné* – although he also used her as a model[1]. There are 381 letters in the Pissarro collection from Madame Julie Pissarro. Their life was rarely financially secure, and these letters, expressed in entirely phonetic spelling, are sometimes vehement outbursts, laced with her practical good sense, loyalty to family, country bluntness, as well as her inability to appreciate intellectual concepts. 'Mother is perhaps a little severe, but do reflect that, if she is hard on others, she certainly is on herself'[2]. Camille Pissarro had attended the Académie Suisse in the evenings of the late 1850s where, with Monet and Guillaumin, he could draw from models and escape when possible to do landscape paintings from nature. There are twelve oil paintings by Camille Pissarro in the Ashmolean Museum, ten from the Pissarro gift.

Oil on panel 16 × 11cm, P&V 14
Pissarro gift 1952. A819

[1] P&V 96, 483 etc. P&V 96
Bührle Collection, Zurich
[2] Lucien Pissarro to his new wife 1 October 1892

3 Camille Pissarro
Paysage à Pontoise 1872 [Landscape in Pontoise]

In 1866 Camille Pissarro moved to Pontoise, and began his first prolonged period of work in the country. Now he could really study and analyse the surrounding landscape. 'I do not paint my pictures directly from nature, I only do studies thus; but the unity given to the action of vision by the human spirit can only be found in the studio. It is there that our impressions, initially scattered, are coordinated, turned to good account to create the pure poem of the countryside. Out of doors one can only grasp the beautiful harmonies which immediately hit the eye: one cannot sufficiently question oneself in order to translate one's intimate feelings to the painting. It is to the search for this intellectual unity that I give all my attention'[1]. The same year, 1892, he wrote 'Nothing, in the end, beats a painting done from memory... the vulgarity disappears and leaves only the glimpse of truth sensed, hovering'[2]. But Camille Pissarro found his primary inspiration outside, and all his life would constantly return to work direct from nature from 'a need for renewal, something which one hankers for, which seems entirely essential to one'[3] – and where he could note the unexpected and the original. The studio was for finishing, re-studying, re-working and synthesising. Solid construction, his own *sensation* and their blending with rich colour – 'the nature of nature and not nature itself'[4] were what he searched for, and around Pontoise, a heavily cultivated chiefly market-gardening area, he could adapt the motif, even the topography, to achieve the desired balance in his landscapes. His vision was never scenic; unlike Renoir and Monet, he was not interested in the leisure of the bourgeois. His figures, at this period usually dominated by the landscape, are at work in it. Here the workers, returning with their load of hay, are almost incidental. The canvas is thinly painted in Camille Pissarro's Impressionist style evolved since 1869. About the time this canvas was painted he wrote[5] 'I will try a field of ripe wheat this summer. There is nothing more cold than the full summer sun; quite the opposite of some colourists, nature is colourful in winter and cold in summer'[6].

Oil 46 × 55cm, P&V 163
Presented by Mr Montague Shearman through the Contemporary Art Society, 1940. A659

[1] C. Lloyd *Studies on Camille Pissarro*, 1986. p.17
[2] JBH III p.220
[3] 1893 JBH III p.216
[4] Brettell, R. and Lloyd, C. *Pissarro and Pontoise*, 1990. p.202
[5] May 1873 JBH I p.79
[6] 5May 1873, JBH I p.79

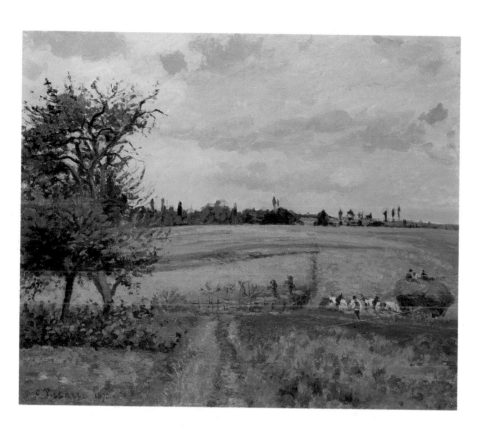

4 Camille Pissarro
Bouquet de pivoines roses 1873 [Bunch of pink peonies]

This oil was painted in Pontoise, in May or June 1873, the flowering season for peonies. The Impressionist style of brushwork is used on the complicated peony flowers. The leaves are more thinly painted, and the table reflects the vase in its brilliant surface. The light comes from above and behind, as if from a skylight, silhouetting the flowers between the viewer and the plain background wall. The semi-circular folded card table has its back turned to the viewer; it also appears in another oil of this period (P&V 197). The Pissarro/Venturi catalogue raisonné shows only thirteen flower pieces out of a total of 1316 oil paintings. Here, the beauty of the flowers has appealed to the artist and he has worked with ease, perhaps in contrast to the intense period of self-analysis in which he was then engaged in his landscape works. Camille Pissarro's painting style changed continually, and he consistently adapted his technique to suit the subject, sometimes even varying it within a single painting.

Oil 73 × 60cm, P&V 199
Pissarro gift 1951. A820

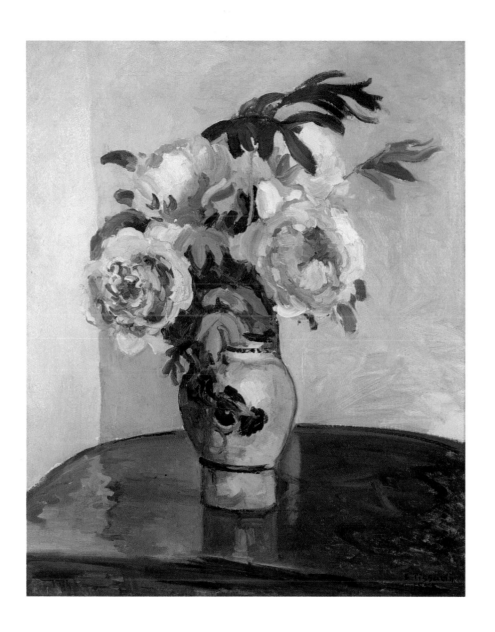

5 Camille Pissarro
Portrait de Jeanne tenant un éventail 1873
[Portrait of Jeanne holding a fan]

Jeanne-Rachel Pissarro, known in the family as Minette, was born in 1865 and died in April 1874 of a respiratory infection. She had not been a strong child, and was already ill in the autumn of 1873. Camille Pissarro believed in homeopathic medicine, and Minette was treated by Dr Paul Gachet – friend and patron of Cézanne, now living near Pontoise. Camille Pissarro painted Minette four times and did one portrait drawing of her. Here the fragile child perches on the side of a chair, the light falling on her from the window to the left of the scene, in a rather bare room, possibly the studio. Her huge, intelligent, eyes in the delicate, rather shy face, confront the viewer. The background is lightly painted in short almost horizontal touches; the figure is more worked, small brushstrokes overlap and combine into a varied but unified surface. Minette holds a Japanese fan: Camille Pissarro's fascination for Japanese art was already strong. 'Japan which interests me immensely, that extraordinary country, so curious in aspect and above all so artistic... Japan, that daring country, so revolutionary in art'[1]. Their process of reduction and simplification matched the synthesis Pissarro was independently searching to apply in his own work, where absolute liberty of technique was as basic a tenet as was freedom in his outlook. The first Impressionist Exhibition, 1874, and its Charter were now being prepared, and Camille Pissarro was working closely with Cézanne at this period.

Oil 55 × 46cm, P&V 232
Pissarro gift 1951. A821

[1] 1873 JBH I p.78

18

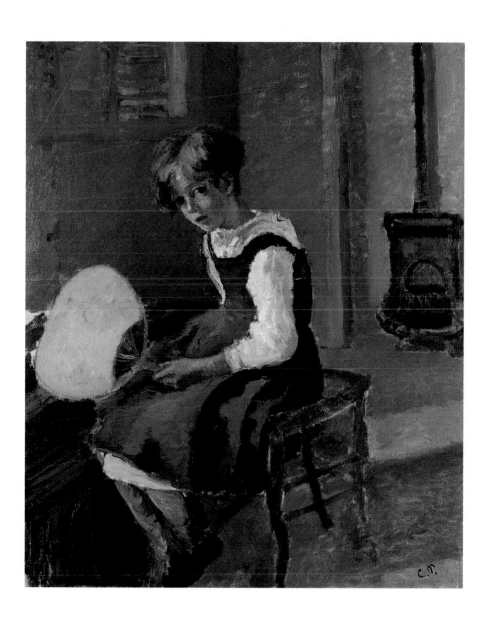

6 Camille Pissarro
Ferme à Montfoucault, effet de neige 1876 [Farm at Montfoucault, snow effect]

Camille Pissarro's great friend the painter Ludovic Piette had a large and attractive house in the Mayenne at Montfoucault[1] where Pissarro had stayed in the 1860s, in 1870, and during lengthy working visits in 1874-1876. The landscape was quite different to that of Pontoise which was peopled, modernised, with roads and railways bringing movement. Here, the fields were enclosed by hedgerows, horizons blocked: the Mayenne region was remote and Montfoucault isolated, and provided the untidy reality of rural life. The 'path of rustic nature' recommended to Camille Pissarro by Théodore Duret in 1873, coupled with the failure of the 1874 Impressionist Exhibition, had confirmed Pissarro in a search which, with his own intense self-analysis and autonomous attitude, he had already begun in Pontoise. This search concerned the integration of the human form and the background, and a new working method. Camille Pissarro reacted to Montfoucault with a more 'rural' facture: thicker paint, occasionally a palette knife, obtaining a rugged yet supple surface, and expression through hue and colour opposites.

In this painting of the enclosed barnyard of the nearby farm, the buildings are treated with short stabs which lengthen in the foreground snow turning to mud. The cold light, untidy thatch and straw bundles are all forcefully expressed, the figure now outlined and integrated. There are numerous figure and animal studies from this period, the first concentrated group as such, which highlight Camille Pissarro's preoccupation with their placing. This was his last visit to Piette, who died in 1878. The wide views of Pontoise demanded a less rugged facture, to which Pissarro reverted.

Oil 54 × 65cm, P&V 283
Pissarro gift 1951. A822

[1] P&V 287. Sterling and Francine Clark Institute, Williamstown, Mass.

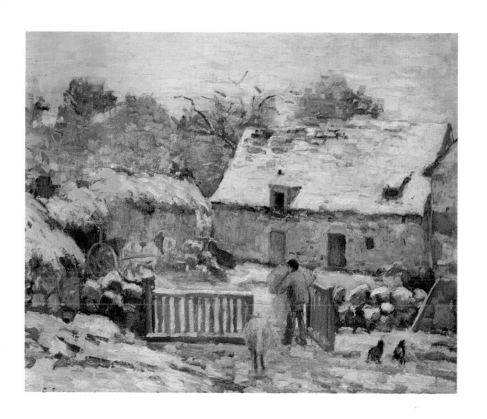

7 Camille Pissarro

Portrait de Madame Pissarro cousant près d'une fenêtre 1878 [Portrait of Madame Pissarro sewing near a window]

This oil again shows Madame Pissarro sewing (see Plate 2) prior to the birth of her fourth son Ludovic-Rodolphe in Paris where the family moved in November 1878, returning again to Pontoise in 1879. Although sometimes thought to have been painted in Paris, this canvas was more probably painted in Pontoise, as the balcony railings match those of another oil painted there[1], whereas a pastel[2] done at the Montmartre address in 1878 shows a different street view and different balcony ironwork. Camille Pissarro's figures are usually purposely featureless, almost faceless: when there is a face it reflects a calm interior peace and detachment, never sentiment – the expression of which he detested. Here the focus is entirely on the face. The paint is thickly worked, the face having an almost enamelled effect. The hues are soft and gentle, fondness and contentment are sensed from artist and subject, whose hardworking nature is also implied.

This painting is an example of how Camille Pissarro could absorb himself into his work: the background to it is of severe poverty in 1878, and the recent blow of Minette's death (Plate 5). 'When will I ever be able to escape from this mess and devote myself tranquilly to my work! My studies are made with no sequel, no gaiety, no spirit...'. 'I have this minute had a letter from my wife, she is so utterly discouraged, even desperate, that caution makes it essential to go and be with her... I am going through an awful crisis, and see no way out'. 'You will certainly understand my anxiety at leaving a woman in an advanced stage of pregnancy alone in the country without money and with two children to care for'[3].

Oil 54 × 45cm, P&V 423
Pissarro gift 1952. A823

[1] P&V 333
[2] P&V 1540
[3] To Murer 1878 JBH I pp. 120, 122, 123

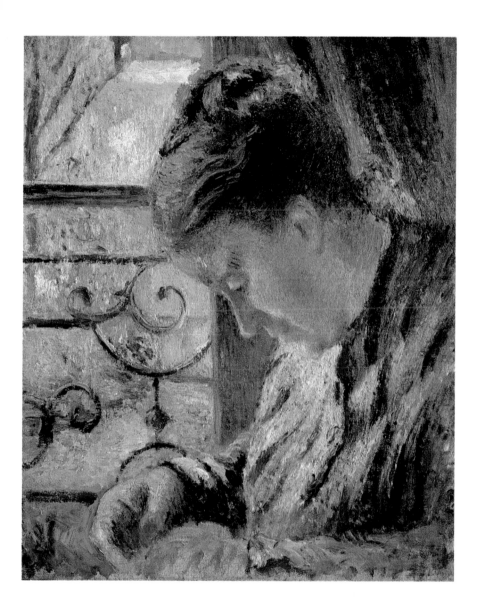

8 Camille Pissarro
Paysage sous bois, L'Hermitage 1879 [Wooded landscape, L'Hermitage]

This softground etching with aquatint and drypoint is from the sixth and final state of the plate originally intended for publication in *Le Jour et la Nuit*, a print journal envisaged by Degas in 1879 to which he, Pissarro, Mary Cassatt, Félix Braquemond and others were to contribute, but which never appeared. The subject was taken from an oil painting[1], thickly painted with brilliant areas of pure colour using colour-opposites which already heralded Camille Pissarro's research and interest before his adoption six years later of the neo-Impressionist technique. The translation of this style to an etching involved highly individual experiments, undertaken with Degas' advice, in combining grounds comprising resin, salt or sugar for the granulated aquatint and broken grey tone effects – achieved by dissolving them in an agent such as pure alcohol, which was poured over the plate, the spirit evaporating when drained to leave a dusting of resin and other grains. The plate itself progressed from a skeletal outline, built up with brushing and scraping, gradually admitting light into the foreground and receding hillside, the figure emerging from its original position behind the tree, still intently gazing towards the hamlet of L'Hermitage, the suburb of Pontoise where Camille Pissarro now lived. Only the final state was professionally printed by Salmon in an edition of fifty on oriental paper. Pissarro, like Degas and Mary Cassatt, made proofs of each state as he built up the effect, each component state thus becoming a signed and annotated print in its own right as well as part of the series: 'they are simply engraved impressions' wrote Camille[2]. Here too lie the seeds of Pissarro's later interest in serial painting – single subject under different lights and effects – which Monet and other Impressionist painters shared. Four states of this plate were exhibited in one frame in the 1880 fifth Impressionist Exhibition. The Ashmolean has an almost complete set of Camille's Pissarro's etchings and lithographs, some printed and annotated during his lifetime, others from subsequent printings arranged by his heirs to complete the editions before the plates were cancelled.

Etching 21.9 × 26.9cm, D 16
Pissarro gift 1952

[1] P&V 444, 1879. Nelson-Atkins Museum, Kansas City
[2] JBH III, 1891 p.39

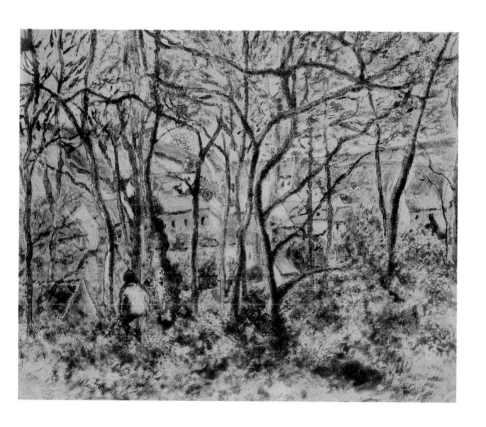

9 Camille Pissarro
Study of female peasant lying on the ground seen from the back 1881-82

This strongly-drawn study is related to the central figure in an oil of 1882[1] painted at Pontoise. The lower part of the body is omitted as here. There is also a pencil study of the same figure weeding, seen frontally[2], and the figure reappears in a fan[3] the same year. Camille Pissarro consistently used a complex and sophisticated preparatory process for his major figure paintings – there are proportionately fewer studies for oil landscapes after 1879. Of the 568 drawings in this collection, less than 100 have no figure in them. By 1882 he had adopted preparatory drawings, almost 'cartoons'[4], for his figures, which are more confident and dominant in the 1880s and move away from the small figures of the 1870s to become 'the rural equivalent of Degas' ballet dancer'[5]. Uniformity of style was never an aim for Camille Pissarro. Under Degas' influence, the figures are now placed at close-range often at an angle. Rural workers were to act as the basis for Kropotkin's new Anarchist state: Camille Pissarro translates this Utopia by showing these workers rooted to the earth, a continuous part of the landscape, dignified and individual in themselves, rarely idle yet never grossly overworked or asking for our sympathy.

Black chalk, charcoal, pastel and gouache 34.4 × 53.7cm, B&L 125
Pissarro gift 1952

[1] P&V 563
[2] B&L 126
[3] Pellé 58
[4] eg B&L 118-123 for P&V 1358
[5] B&L p.22

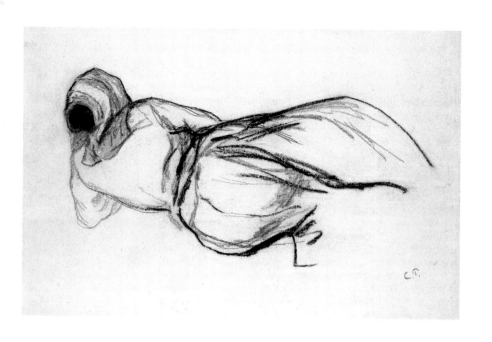

10 Camille Pissarro
Portrait of Lucien Pissarro 1883

Lucien (b.1863) was the eldest of Camille and Julie Pissarro's five surviving children. This large pastel was drawn between August and October 1883 when Lucien returned to Osny (where the Pissarros lived from December 1882 until spring 1884) from London where he had been sent to learn English. Camille Pissarro only used pastel spasmodically, at this period again probably influenced by Degas. The mastery of handling and colour give a brilliant lustre to this portrait of a thoughtful figure in repose, arms crossed, yet vitally alive and full of energy. The highly-worked face has white over the flesh tones which glow through it; the whole image is fresh and spontaneous and alert. There are an etching[1] and a lithograph[2] as well as a chalk sketch of Lucien[3] by Camille Pissarro.

Drawing held a central rôle for Camille Pissarro during the 1880s while he worked out his stylistic problems. In May 1883[4] he wrote to Lucien 'I go on gently along the path I have worked out for myself... deep down I only vaguely see if it is good or not. I am much disturbed by my rough and rugged execution, I would rather have a more even facture, uniting the same savage qualities but without the disadvantages, the rough surface patches, which only allow my canvases to be seen in a frontal light; that is where the difficulty lies, without counting the drawing!' From 1885 drawing also became an essential antidote to the slow oil technique required when Camille Pissarro adopted the neo-Impressionist technique.

Pastel 55.2 × 37.6cm, P&V 1563, B&L 157
Pissarro gift 1952

[1] D 91
[2] D 192
[3] B&L 155b
[4] JBH I p.202

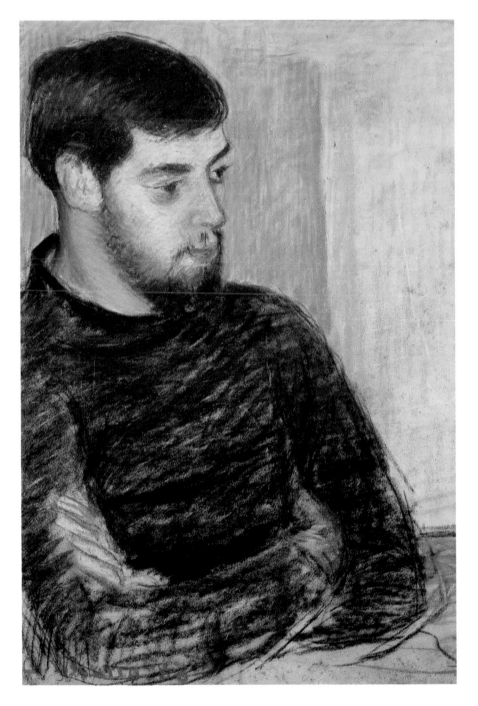

11 Camille Pissarro
Briqueterie à Eragny 1885 [Brickyard at Eragny]

Camille moved to Eragny-sur-Epte in 1884, and lived there for the rest of his life. This small village was further from Paris than Pontoise or Osny, but quieter, less modernised, and was near Gisors – a small market town in the Normandy region. The brickworks, by then hardly active, were owned by M. Delafolie, whose house appears in two oils[1] and a drawing[2], seen from the Pissarros' home over the garden fence. M. Delafolie provided cider for Camille Pissarro and for Monet in 1885, and occasionally carried parcels for the Pissarros to or from Paris on his journeys there. Camille Pissarro painted four other oil paintings showing this brickworks 1885-88, one (P&V 679) from a similar position to this one: only the 1888 oil[3] uses the point technique, which Camille Pissarro adopted gradually during 1885. Here the short, often horizontal strokes announce the change.

The turbulent late afternoon cloud effects, a veiled sun upper left, dominate this painting and lift the viewer from the run-down, slightly decrepit ex-industrial scene with its water-pump, which seems about to be reconquered by the natural landscape. The village and church spire of Bazincourt appear on the horizon. 'I am in the middle of a transformation and am impatiently awaiting some sort of result...' 'I will bring you some canvases at the beginning of August... many have gone wrong this year' he wrote that summer to Durand-Ruel[4].

Oil 38 × 46cm, P&V 661
Presented by Mr F. Hindley-Smith, 1939. A630

[1] P&V 678, 733
[2] B&L 192
[3] P&V 724, J. Paul Getty
 Museum, Malibu
[4] JBH I p.339

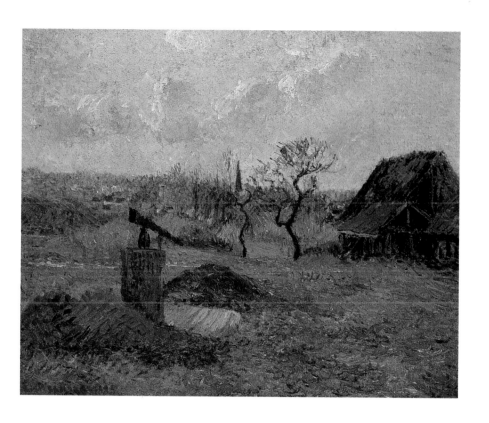

12 Camille Pissarro
Village d'Eragny, esquisse 1885 [The village of
Eragny, sketch]

In June 1885 Camille Pissarro wrote to Durand-Ruel 'I
have set to work on some small canvases. My aim is to
be bright and luminous with very supple landscapes,
that is, with the least possible difference between the
opposing colours. It is not easy to explain… grey weather
suits the idea the best. However that too has something
mis-sing from the point of view of calmness in execution.
I am searching for something I have not found; it is very
interesting, as it gives me a lot of trouble! This has gone
on for several years now…'[1]. That August he wrote to
Lucien 'I have at last found my technique which had
been tormenting me for a year. I am more or less sure of
what I want'[2]. This painting was apparently sketched
outside in front of the motif, but never completed in the
studio. The subject is not repeated from the same posi-
tion. The empty road into the village of Eragny cuts
through the banded composition, only the sky and the
left middle-foreground being much defined. Camille
Pissarro's house, still rented at this stage but later
bought, was further up the road on the left.

Oil 55 × 35cm, P&V 666
Pissarro gift 1952. A824

[1] JBH I p.335-6
[2] JBH I pp.341-2

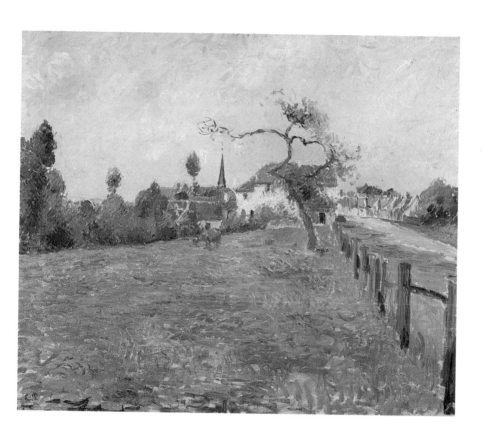

13 Camille Pissarro
Vue de ma fenêtre, Eragny 1888 [View from my window, Eragny]

'It seems that the subject is unsellable because of the red roof and the farmyard, exactly what gives its whole character to the painting, which has a *primitive-modern* stamp to it... What they do not like are the brickyard houses, precisely what I had so worked on! If you could see how calm and simple that painting is, stable...'[1]. Durand-Ruel's dislike of this painting, described above, may be the reason why this canvas, which was first exhibited in the 1886 Impressionist exhibition in the same room as Seurat's *La Grande Jatte*, was reworked and re-signed over the 1886 signature in 1888. The small stabs of paint are not the minute dots associated with neo-Impressionism, rarely used in oil by Camille Pissarro[2]. This broader brushwork still uses pure complementary colours. The whole surface vibrates with freshness. 'He expresses the scent, simultaneously restful and powerful, of the earth'[3]. Camille Pissarro had worked from windows previously: later he was to do so increasingly (see Plates 20, 23). Here it enabled him to achieve both distance in the view and a certain detachment needed to render the complicated scene: poultry-yard to the left, with its hutches; kitchen-garden to the right, where Madame Pissarro grew vegetables and flowers. The large barn on the left was converted into a studio in 1892. Camille Pissarro's gradual movement away from the point facture can be followed in his letters: 'I am convinced of the progress there is in this art' May[4]. November[5]: '...how long it takes! You will not believe that I take three or four times as long to finish a canvas or gouache... I despair of it.' September[6]: 'I have not been able to resolve the question of pure tone divided without hardness... what can one do to have the qualities of purity, of simplicity from the point technique, and also the richness, the suppleness, the liberty, the spontaneity, the freshness of *sensation* from our Impressionist art? For the point is lean, inconsistent, translucent, more monotonous than simple'. And by February[7]: 'At the moment I am searching for a way of replacing the point... the technical work does not seem to me to be fast enough and does not respond simultaneously enough to the *sensation*'. Output also dropped alarmingly: 1885 – 34 oils; 1886 – 17 oils; 1887 – 9 oils; 1888 – 8 oils; 1889 – 9 oils.

Oil 65 × 81cm, P&V 721
Pissarro gift 1950. A794

[1] July 1886 JBH I p.64
[2] see P&V 699
[3] JBH Vol II p.171 note 1
[4] JBH II May 1886 p.45
[5] JBH II November 1886 p.74
[6] JBH II September 1888 p.224
[7] JBH II February 1889 p.216

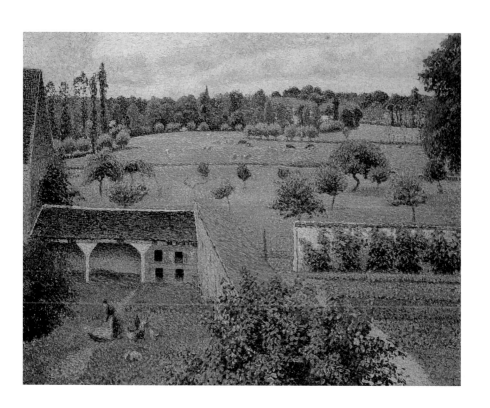

14 Camille Pissarro
Rameuses de pois 1890 [The pea stakers]

This design for a fan, unique in this shape, was painted in gouache with chalks on grey-brown paper in the last two months of 1890 and given to Lucien Pissarro for the New Year 1891 – surprisingly thus a winter studio work. The following year Camille Pissarro painted the subject again, in an upright format[1], once owned by Monet, transposing the two background figures. These works, with one of 1884[2], are often cited to demonstrate the unity and harmony of style achieved in Camille Pissarro's vision of a rural Arcadia – an idyllic dance of form, graceful women as part of nature, and the communal aspect of rural work. The figures planting sticks to hold the growing peas, their faces expressionless, allow no intrusion. The high horizon-line adopted by Camille Pissarro over the previous decade allowed the figures to be placed almost in silhouette, as in a fresco, against a background landscape, as part of it and of the earth. Here the detailed imaginary background combines elements seen in P&V 781 or later oils of Eragny[3] where the curve of the river is shown, or the cottages turned around.

Camille Pissarro had painted fans since 1878. The asymmetrical format appealed to him: and they sold well, in common with vast number of fans by then being imported from Japan. The 1890 Paris exhibition of Japanese prints renewed his interest – there are eleven fans recorded in 1890 out of eighty in 1875-85, all unmounted. By 1890 he was painting more freely, dividing pure tone more fluidly without waiting for the colour to dry. By 1891 he had completely abandoned the point technique.

Gouache with traces of black chalk 40.7 × 64.1cm, P&V 1652, B&L 219
Pissarro gift 1952

[1] P&V 772
[2] P&V 1393. St Louis Art Museum, St. Louis, Missouri
[3] P&V 818, 868-8, 872

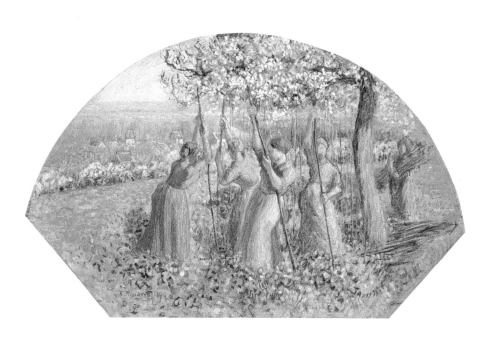

15 Camille Pissarro
Study of the orchard of the artist's house at
Eragny-sur-Epte 1890

This watercolour, over pencil, shows the same view as
an oil of 1893[1] and a crayon drawing c.1902[2], of the lower
orchard and meadow so often painted by Camille
Pissarro, here in summer. There are thirty-six water-
colours in this collection. To Camille Pissarro their use –
apart from times such as in 1884 and 1889 when they
were selling and his oils were not – is described to
Signac[3]: 'I have done a lot of watercolours which help
me to do my paintings, and even some little bits of pas-
tels! I recommend watercolour to you, it is invaluable,
the fluidity of a sky, certain translucencies, a whole heap
of small indications which a slow work cannot grasp,
effects being so fugitive'. And, after he ceased to use the
slow point technique: '...remember that the watercolour
is a good way to help one's memory, above all for fugi-
tive effects; watercolour shows the inexorable, the
strong, the delicate, so well. And drawing is indispens-
able'[4]. Here he uses a rapid technique, often as in the
grass using the whole side of the brush. The scene
is calm, looking across the willow-lined river Epte to-
wards Bazincourt just visible between the trees, incor-
porating a sense of cool shadows and hot sun. Camille
Pissarro abandoned watercolour in his last years: 'it is so
inconsistent as a material'[5].

Watercolour over pencil 28.3 × 22.5cm, B&L 238
Pissarro gift 1952

[1] P&V 850
[2] P&V 1607
[3] 1886 JBH V p.404
[4] 1891 JBH III p.81
[5] 1903 JBH V p.381

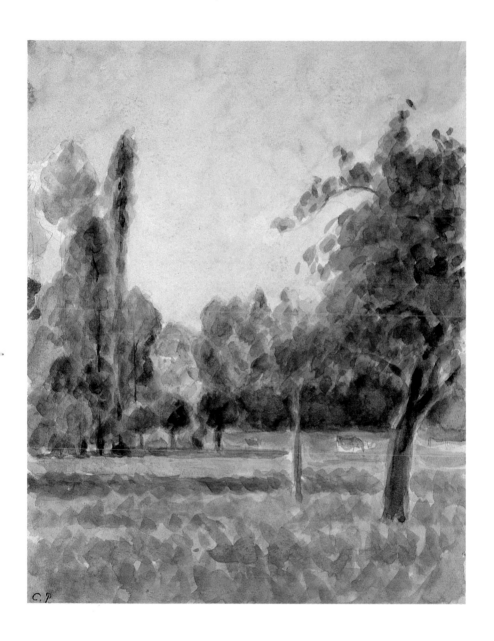

16 Camille Pissarro
Le Marché de Gisors, rue Cappeville 1893
[The market at Gisors, rue Cappeville]

This drawing was originally intended for a wood-engraving to form part of Phase II of the *Travaux des Champs* series drawn by Camille Pissarro, to be engraved on woodblocks and printed by Lucien Pissarro – a series inspired by Hokusai's *Manga*. Only Phase I of this series was ever published – an Album of six wood-engravings without text in 1894. A number of Camille Pissarro's drawings for subsequent phases were used by Lucien Pissarro after his father's death to illustrate E. Moselly *La Charrue d'Erable*, 1912; and a section from this image appears there p.67. This scene, which Camille Pissarro adapted for an important colour etching in 1894[1], is completely documented, and shows how draw-ings were used extensively in the preparation of his prints. The setting derives from an oil[2] of 1885 which itself uses elements from gouaches[3]. The wood-block sequence began on 5 October 1893 when Camille Pissarro ordered the block. He made preparatory draw-ings for a discarded horizontal format of this scene[4], and this drawing for the upright version which he then drew directly onto the wood-block, although the horizon-line is higher there. The block was posted to Lucien in mid-November 1893, apparently adapted by him but never engraved, perhaps because Lucien was then engraving the blocks for Phase I, perhaps due to the complicated grey half-shadow effect for which they were searching, or perhaps because the size was too large for Phase II. Camille Pissarro had been experimenting with etching since April 1894 with renewed interest, and on 26 May he sent Lucien a hand-coloured proof[5] of this scene translated to an etching plate smaller than the wood-block. In December 1894 he was waiting for the colours to print it; and in January 1895 the printed etching was sent – there had been seven states to it. The French market place, here that of Gisors 3 km south of Eragny, was treated regularly in Camille Pissarro's work from 1881 in various media. Peasant and bourgeois figures had appeared, usually separately, in his earlier land-scapes, the bourgeois providing a certain social tension. At market they are perforce brought together in an ideal setting for social observation.

Black and chalk, ink, grey and brown washes with white
27.5 × 10.9cm, B&L p.52
Presented by Mr J. Bensusan-Butt, 1990. 120

[1] D 112
[2] P&V 690
[3] P&V 1400, 1401
[4] B&L 295 and a gouache in a private collection
[5] Possibly B&L 299

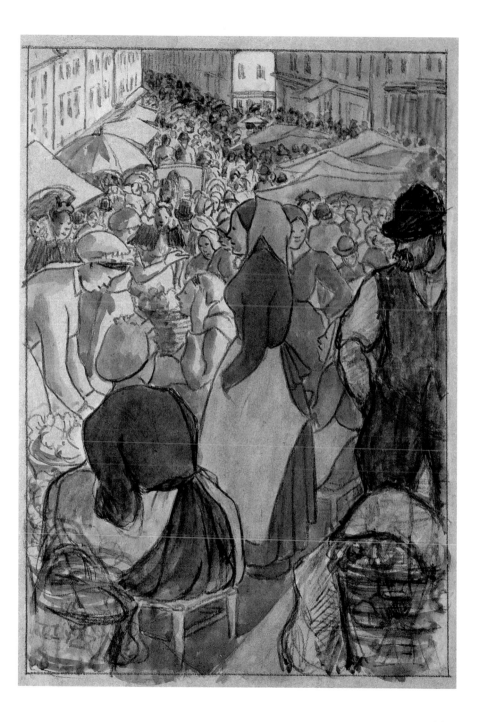

17 Camille Pissarro
Baigneuses luttant 1894 [Bathers struggling]

In 1894 Camille Pissarro could at last afford his own,
second-hand, printing press, thus allowing him to
achieve exactly the inking, wiping, atmospheric effect
and tone he wanted for his etchings and lithographs, in
preparation for the final print-run. 'He uses too much
sauce' was to be his reaction to some of Delâtre's pro-
fessional printing work for him[1]. Pissarro had started
making lithographs in 1874 – he had etched since 1862 –
and he approached the medium with typical creative
freedom. He had hitherto attempted bathers only once[2].
Many of Pissarro's figure studies were made in extensive
and direct preparation for prints: he could thus paint the
image in lithographic ink onto the zinc plate, modelling
the figures with translucent grey washes. This litho-
graph forms part of a series of oils, gouaches and prints
of female nudes begun in July 1893, probably inspired by
Cézanne's oils. Cézanne's lithographs of the same sub-
ject were not made until 1896. Camille described his
progress: 'I have also prepared some arrangements of
peasant women bathing in a clear stream, under the
shadow of willows, this tropical heat inclines one to
motifs filled with shade along a river, I seem better to
sense their great poetry'[3]. In January 1894[4]: 'Since I have
had the press I have been doing Bathers'. In April[5]: 'I
have been doing a whole series of printed romantic
drawings which seemed to me to have a rather amusing
appeal, quantities of Bathers in all sorts of poses in para-
dise landscapes'. By January 1895[6]: 'I am also having
some lithographs on zinc printed by Taillardat, some
Bathers struggling, playing in the water'. Only six or
seven impressions of this lithograph are known: the date
is thus 1894 for the image, 1895 for the printing, which
he again mentioned in May 1895[7]: 'I am just now having
a landscape lithograph printed of Bathers playing... I do
not know what the caprice of tone will have produced...
I am waiting for the trial proofs'. Camille Pissarro's
graphic work was done for pure pleasure 'If they did
not amuse me I would not do them'[8]. 'What a pity
that people do not want my prints. I find them just as
interesting as the painting that everyone does, and there
are so few who properly notice the print'[9].

Lithograph 18.5 × 23.3cm, D 159
Pissarro gift 1952

[1] 1895 JBH IV p.26
[2] 1876, P&V 376
[3] July 1893, JBH III p.341
[4] JBH III p.418
[5] JBH III p.445
[6] JBH IV pp.25-6
[7] JBH IV p.66
[8] 1896 JBH IV p.216
[9] 1895 JBH IV p.54

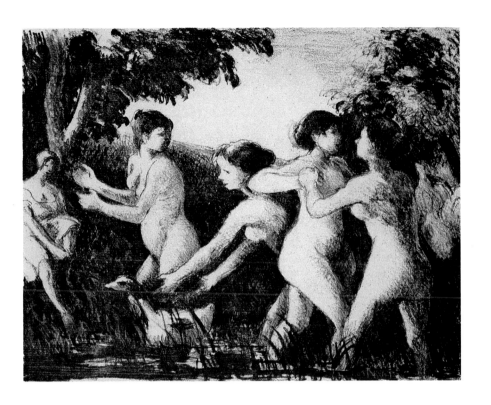

18 Camille Pissarro
La Batterie mécanique 1894-5 [The mechanical thresher]

The wood-block and that referred to on p. 40 (Whitworth Art Gallery, Manchester) are the only ones known where Camille Pissarro drew directly onto the block, here using pen and ink: this block also being intended for Phase II of the *Travaux des Champs* in collaboration with Lucien, although it is not mentioned in their correspondence. From indications made by Lucien on Camille's Phase II drawings, it is clear that three of them were photographed onto the blocks for cutting – his usual practice by that date. This block came from the same supplier and is the same size as two used in the published Phase I; it is composed of five pieces of pearwood. The detailed technique common to the drawings for the proposed contents of Phase II (twelve subjects related to changing seasonal activities of which seven are identified[1]) was found, in the four blocks actually cut, to produce too strong a contrast between the black and white areas, and with the proposed typeface for an accompanying text. The pressure of other work also intervened and Phase II was abandoned. There is a pencil and ink drawing over a tracing from this image in the collection[2]. The scene was later re-drawn by Camille Pissarro divided into two[3] for Phase III, where a chiaroscuro effect was intended, but completion was prevented by his death in 1903. One of these halves[4] was engraved by Lucien to illustrate A. Moselly *La Charrue d'Erable* 1912 opp p.22.

The subject was taken by Camille Pissarro from his Montfoucault oil of 1876[5]. The rare introduction of agricultural machinery in no way dominates the scene, it is the rhythm of a co-operative activity which interests the artist, the glorification of work. Here there is no place for the bourgeois or their ideals: harmony and equality predominate.

Ink on wood-block 12.2 × 17cm
Pissarro gift 1952

[1] B&L 333-342
[2] B&L 342
[3] B&L 376-7
[4] B&L 376
[5] P&V 367

19 Camille Pissarro
Bath Road, Londres 1897

Lucien Pissarro, with his wife and daughter, moved to 62 Bath Road, Bedford Park, London in April 1896 from Epping where they had lived upon arrival in England in 1893. Shortly afterwards Lucien had the first of a series of strokes suffered that year. Camille Pissarro came to stay with him, arriving 7 May. On 18 May he wrote that Lucien 'having been between life and death for a fortnight' was now out of danger[1]: Camille remained until his son was strong enough to travel back with him to France on 20 July to convalesce. By 10 June Camille was hard at work, painting six known oils from the front and the back of the rented house. This painting shows 37 Bath Road opposite, the last house on the north side of the road having then been completed, and the front garden of Lucien's house with a woman and child (probably Esther Pissarro, certainly their daughter Orovida b.1893). The composition is reminiscent of Camille's 1870 Louvenciennes oil[2] where Julie and the 5-year old Minette were shown.

The quiet, peaceful scene appears more as a landscape than a town painting. Bedford Park, indeed, was one of the first 'garden cities' of London, built in the 1870s by a developer chiefly using the architects E.W. Godwin and Norman Shaw, and had at once attracted residents of an artistic or progressive nature.

The painting is unfinished. This was Camille Pissarro's last visit to London, where he had previously worked in 1870-71, 1890 and 1892. 'It is odd, in spite of the drawbacks, London has often attracted me, and yet I have never been able to make my paintings of London popular'[3].

Oil 54 × 65cm, P&V 1009
Pissarro gift 1951. A825

[1] JBH IV p.358
[2] P&V 96 Bührle Collection, Zurich
[3] to Monet 1900 JBH V p.423

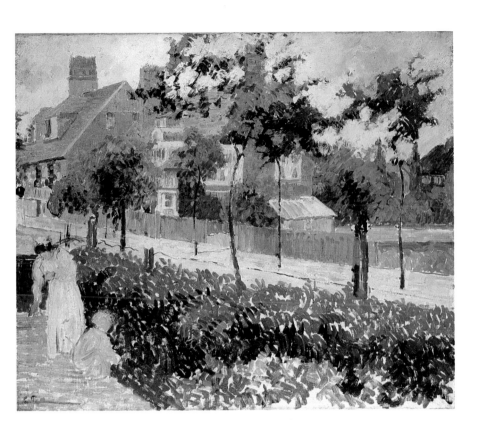

20 Camille Pissarro

Le Jardin des Tuileries, temps de pluie 1899
[The Tuileries gardens, rainy weather]

By 1889 Camille Pissarro had developed an eye problem
first noticed in 1878, which prevented him from working
outside in cold or wind. This oil is one of a series of four-
teen, six of this view, painted from an apartment at 204
rue de Rivoli, Paris, which he rented from January 1899
to avoid the winter at Eragny and to have new subjects
to paint. It was 'opposite the Tuileries with a superb view
of the garden, of the Louvre to the left, houses in the
background, the quais behind the trees of the garden, to
the left the dome of the Invalides, the belltowers of
Sainte Clotilde behind the dense groups of chestnut
trees. It is very beautiful. I shall have a fine series to do'[1].

Although Monet painted series in quantity from
1886, Camille Pissarro's serial paintings began tentatively
in Rouen in 1883, developing more fully from 1896
onwards. They are chiefly townscape series, the later
ones all painted from windows as here. Although their
motifs were usually quite different, to both painters their
interest in these intensely studied series lay in the ren-
dering of light and weather at different times of day and
season.

This painting, in especial contrast with one from
the same position under the sun[2], shows the lashing rain
and wind, a cold, wet weather scene. The artist looks
down on the complicated formal garden design with the
viewer: again, there is a detachment, almost an invisible
window-frame. 'Up until now I have only started grey
weather and rain effects. Since our arrival we have only
had gloomy weather and howling wind. It whistles and
makes a deafening din over that great open space'[3]. By
29 January he had nine canvases under way, by March
fourteen, of which twelve were practically finished. The
silvery atmosphere of Paris with its characteristic grey
effects is captured in the luminous horizontal brush-
strokes of the sky. 'I am struggling with age and really I
never do quite what I intend, the cup is so far from the
lip'[4].

Oil 65 × 92cm, P&V 1102
Given by Mrs F. J. Weldon 1937. A492

[1] 1898 JBH IV p.522
[2] P&V 1101
[3] January 1899 JBH V p.9
[4] To Monet 1900 JBH V
 p.423

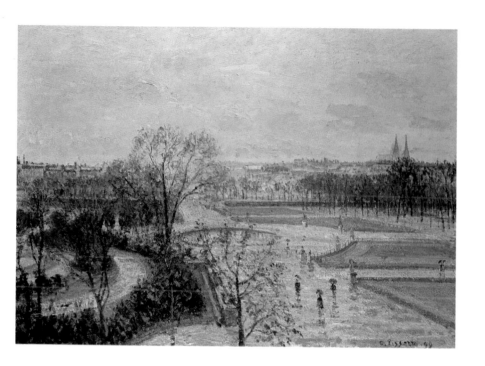

21 Camille Pissarro
Automne, Brume du matin, Eragny 1902
[Autumn, morning mist, Eragny]

'I can no longer abide the summer with its great monotonous grey, the dry horizons where everything can be seen, the torment of the great heat, the sagging and sleepiness... the *sensations* re-awaken in September and October...'[1]. Camille Pissarro loved the autumn: nothing was comparable to its last days for fineness and delicacy of tone, seen here from the studio window from the same position, morning rather than evening, as Plate 22. It is the effect of light, the interaction of season, air and space[2], for which he searched, not the precise rendering of the often repeated view – trees change position, size, shape to suit him. He had returned to Eragny after his Dieppe series on 3 October: 'I have several things in hand and I am continuing some unfinished ones from last year'...[3]. 'I have not dared to work outside although it would have been possible, because of my rheumatism and general worn-out state!'[4]. During these last years he felt great pressure to continue a large output – sales were variable – and re-stock his studio, producing 46 oils in 1900, 49 in 1901, 64 in 1902 and even 42 in 1903 before his death that year. As well as his own household, where two children still lived, he paid monthly allowances to his older children and expenses for one grandchild. 'Besides, I cannot live without working hard, it has become second nature for me'[5].

This painting shows the upper part of the left side of the orchard. The three apple trees in the foreground often appear – younger as in one of 1895[6], or as in Plate 22. Two figures work together, probably picking the remaining cabbages, although their exact occupation is not defined. They are turned from the viewer, intent only on their work. The last decade of Camille Pissarro's life saw him using ever thicker paint layers.

Oil 46 × 55cm, P&V 1265
Pissarro gift 1951. A826

[1] 1893 JBH III p.368
[2] Brettell, R. and Pissarro, J. *The Impressionist and the City*, 1992, p.LII
[3] JBH V p.271
[4] JBH V p.280
[5] May 1903 JBH V p.336
[6] P&V 908

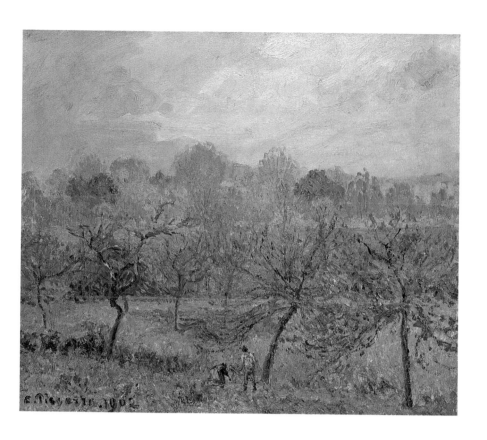

22 Camille Pissarro
Soleil couchant à Eragny, automne 1902
[Sunset at Eragny, autumn]

Unlike the majority of Camille Pissarro orchard scenes, this view from the studio window has no figure at work. The powerful, heavy paint surface and close colour values are full of the resonance of autumn. The complex weaving of branches allows the viewer to distinguish the fence between the orchard and meadow, heightened with bright pink touches, while strokes of vivid green highlight the orchard floor and its row of cabbages. There is no house visible through the trees (Plates 15, 21), and the world is shut out. Camille Pissarro is at the summit of his technical experience, and now interprets his motifs in complete harmony – the countryside for nature, peace, renewal, the ideal vision of traditional and continuous rustic life: the townscapes for the modern world, its changes and contradictions. There were to be only two more orchard views, in early 1903. 'As soon as I have finished my work here (Le Havre, July 1903)[1], I shall return to Eragny to work on trees'. Instead, he fell ill.'...'that thread which holds me here is near enough to unwinding altogether'[2] he wrote in 1903, presaging his death four months later.

Oil 73 × 92cm, P&V 1268
Pissarro gift 1950. A795

[1] JBH IV p.356
[2] JBH V p.358

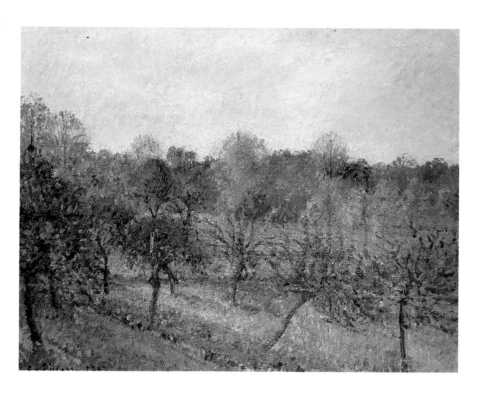

23 Camille Pissarro
Quai au Havre 1903

The urban scenes of Rouen, Paris and Dieppe culminated here in Le Havre where Camille Pissarro painted his last works between July and September 1903. He naturally chose to show everyday urban life rather than leisure. The lack of social order also appealed to him, pedestrians, workers, carriages mix freely in any town. People are merely indicated, here just part of a working port scene waking for the day's work while the middle-ground industrial and commercial installations remain wrapped in mist, air, smoke. The abundant use of white gives an opaque, luminous unity to the scene which is painted on batiste (a cambric) for a more supple and soft rendering. This oil, from a series of eighteen of which eight show this view (though only two include the corner building and Bar on the left), was painted from his room at the Hotel Continental on the main quay of the inner harbour: '...it is clean, large, very smart, probably expensive, the cooking pretty poor (grand French cuisine) – the English and the money-bag types lick their chops. One cannot have cider, the manager having announced to me that the establishment was too self-respecting to keep the stuff! Crafty! You know, the motif is completely secondary to me; what I reflect upon is the atmosphere and the effects. A mere nothing is good enough for me. If I followed my own wishes I would stay in just one town or village for years, unlike many painters; I would finish by finding effects in the one place...'[1]. Sales were poor, and a town series appealed to his collectors. 'The Port of Le Havre is hardly esthetic, but one gets used to it and ends by finding great character'...[2]. 'All day long from morning until nightfall I see the great transatlantic steamers and others passing in front of my window, with the docks, the traffic, it is grandiose, I think I have got an interesting new series... and then there is the pot to keep boiling! One cannot trifle with that'[3]. 'I am nailed to my post'[4]. The weather was poor at the end of July and this oil is from the grey-weather group in the series. Camille Pissarro fell ill in Paris on his return, and died there on 13 November 1903.

Oil 24 × 29.5cm, P&V 1303
Pissarro gift 1951. A827

[1] JBH V p.351
[2] JBH V pp. 354-5
[3] JBH V p.357
[4] JBH V p.365

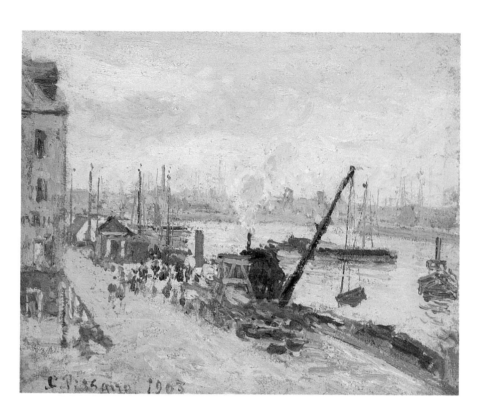

There are 770 letters from Camille to Lucien Pissarro in the archive, as well as eighty from Camille to other people. These have all been published[1] and they constitute the largest existing holding of Pissarro's letters. Camille wrote to Lucien every week when they were apart, sometimes more than once. These letters are of inestimable value for an understanding both of the work and the character of father and son. Camille Pissarro wrote with speed and conciseness of style; the reader is presented with a simultaneous rush of ideas and opinions which stimulate the imagination. Often, in the discussion of Lucien's work or of their joint projects, there are sketches to illustrate Camille's criticisms and suggestions. His handwriting varies little over the span of thirty-seven years represented in this collection, varying chiefly with the nib used. His soundness of judgement, irony, humour, occasionally anger, are uninhibited and draw a vivid picture of the time, the people, and politics of late nineteenth-century France.

[1]JBH

Illustration:
Camille to Lucien Pissarro
18 December 1901
Pissarro gift 1952

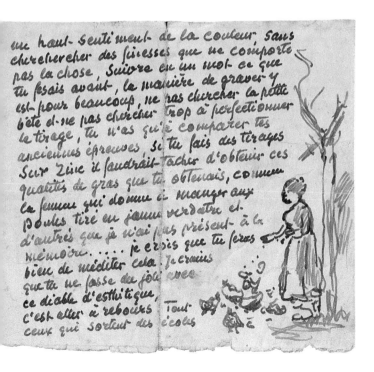

25 Lucien Pissarro
La Maison de la Sourde (La Maison de l'Anglais)
1886 [The deaf-woman's house *or* The English-
man's house]

This neighbouring house at Eragny was also painted
twice by Camille Pissarro in 1886, and again in 1895[1],
from various angles. Lucien Pissarro had adopted the
neo-Impressionist facture in 1886, the year in which he
also exhibited for the first time in what was to be the last
Impressionist exhibition. This oil was finished in time to
be included that autumn in the Salon des Indépendants
1886 show: an earlier crayon drawing showed a girl's
figure in the central section of this scene[2] – which was
used in a different setting for an 1891 wood-engraving
Sister of the Wood. Although the background is painted
with the point of the brush in small dabs, the side of a
fine brush is used for the field, and the colours are divi-
ded. Lucien Pissarro was to exhibit regularly with the
Indépendants until 1894, with the Peintres néo-
Impressionistes 1892-5, and with the avant-garde Les
XX Group in Brussels in 1890 and 1892. He ceased to use
the fine point technique by 1891, the strokes getting
gradually wider and rectangular and for a time the paint
surface thickly built up. Lucien Pissarro kept a record
book of the oils he painted, as well as a catalogue of his
wood-engravings, now in the Ashmolean Museum.

Oil 58 × 72cm, AT 9
Pissarro gift 1952. A835

[1] P&V 696, 702, 910
[2] 77.1605

58

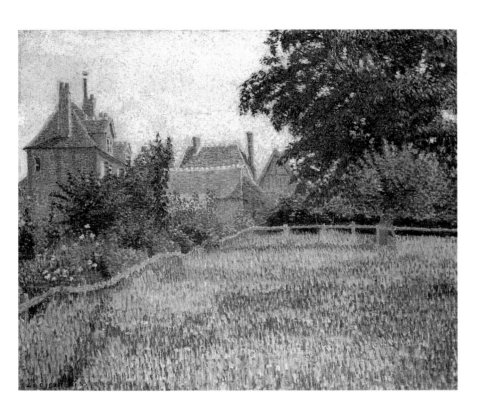

26 Lucien Pissarro

Gelée blanche, Chiswick 1906 [White frost, Chiswick]

Lucien Pissarro had moved from France to live in London in 1890, partly in order to pursue a more receptive public for his wood-engraving, (of which he published a portfolio in 1893), subsequently founding the Eragny press (see p. 68). For a time his health and printing work obliged him to stop painting, but by 1905 he had begun again, joining the Fitzroy Street Group around Sickert in 1907. Here his experience and knowledge of the Impressionist and neo-Impressionist facture and use of colour were appreciated: in England these artists were associated with the avant-garde. From them evolved the Camden Town Group, which first exhibited in 1911 and of which Lucien Pissarro was a founder-member. This oil painting, first exhibited with the New English Art Club in 1912, shows part of the garden at his house 'The Brook' in Stamford Brook Road, Chiswick. The frost lies on the lines of turned earth: it is the thickness of paint that makes the tree branches on the right stand out in silhouette against the mist behind, and again on the dug earth there is a thick crust of oil paint. Generally speaking, after 1908 the paint surface is more lightly covered, and from about 1913 Lucien Pissarro's technique varied little for the rest of his life. Unlike his father's work, there are seldom figures in his landscapes. He tended to paint out of doors in front of the motif, searching for light effects and atmosphere in his views but without a serial repetition of subject.

Oil 39 × 46cm, AT 107
Pissarro gift 1952. A842

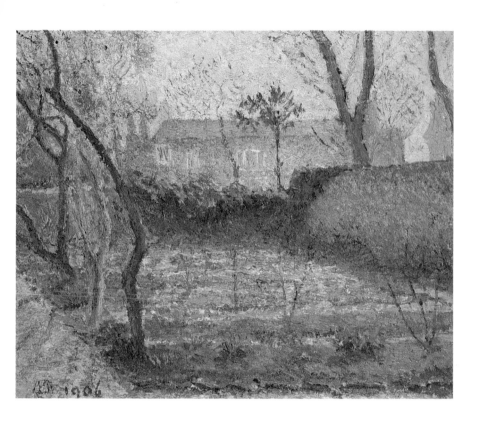

27 Lucien Pissarro
The Coastguard's House, Ecclesbourne 1918

Lucien Pissarro spent the first six months of 1918 paint-
ing in and around Hastings, where he took lodgings.
This drawing in coloured crayons and ink was made
from the same general position but slightly forward and
to left as an oil painting[1] that June. There is also a draw-
ing in a sketchbook[2] for the central part of the image.
When possible in poor weather he worked from a
window: in Hastings fog sometimes prevented even this.
His letters frequently give accounts of the troubles he
had working out of doors, both with passers-by and the
elements: 'I found a place between the trees where I am
not too conspicuous ...It is such a big town, with people
walking about everywhere – but so far they have not
detected me between my trunk of trees (caricature
sketch, with easel)'[3], or again 'Somehow the wind came
from the North en enfilade along the vale and I could not
stand my easel'[4]. His watercolours and mixed-media
drawings sold well, and were normally done for that
purpose rather than in preparation for oil paintings, for
which he used sketchbooks.

Coloured crayons and ink 19.2 × 27.7cm
Pissarro gift 1952

[1] AT 177
[2] Sketchbook 1918 (63) p.88
[3] 29 January 1918 to his
 wife
[4] 6 March 1918 to his wife

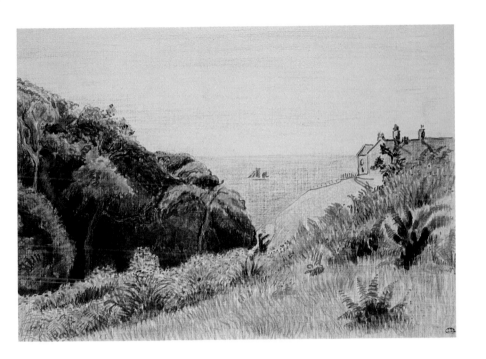

28 Lucien Pissarro
Genets de Malaginesta, Le Brusq 1925 [Broom at
Malaginesta, Le Brusq]

Lucien Pissarro would spend several months each year
painting in the English countryside. Apart from visits to
his mother at Eragny, where he would usually only have
time for watercolours and sketches, his first group of oils
in France after his father's death was in Brittany in 1910;
then 1922 in the Var, where he eventually bought a small
house in 1929 after his mother's death. This 1925 visit to
Le Brusq, where he spent the first five months of 1925,
was very productive – 25 oils. Here the broom flowers
are thickly painted, as is the hazy sky, while the rest of
the landscape has a more even facture. Lucien is study-
ing the expression of light, and here successfully cap-
tured the sense of June heat. He had written to his
daughter Orovida[1]: 'This place which is lovely is so
exposed to the wind that it is almost impossible to work.
This year is very cold and I am obliged to work with
leather jacket and sometimes gloves!'. After the 1914-18
war Lucien Pissarro concentrated solely on his painting
which he continued until the year before his death. He
exhibited regularly in England at the Goupil Gallery, the
New English Art Club, and from 1922 at the Leicester
Galleries. By that time he scarcely ever exhibited in
Paris. He had become a British national in 1916.
Although his work sold well, Lucien was occasionally
obliged to sell paintings inherited from his parents to
provide income. He died in 1944 in Somerset, where he
had rented a cottage during the war.

Oil, AT 416
Presented by Mrs W. F. R. Weldon 1937. A491

[1] 25 March 1925

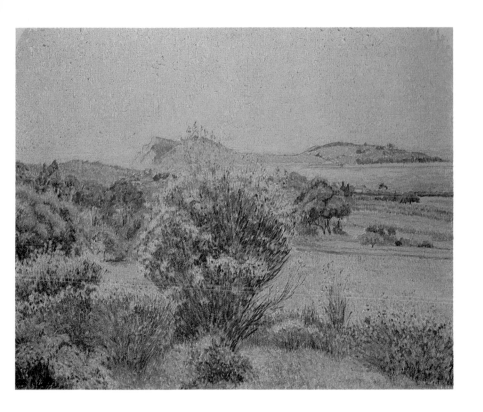

Camille Pissarro frequently stressed the importance of drawing to his children in order to develop the technical skills of hand and eye, and to record their spontaneous responses to the motifs. Lucien Pissarro followed this advice closely: there are eighty-nine sketchbooks in this collection covering his working life in which about 350 of the pages are initial ideas for wood-engravings and 142 for oil paintings. Sometimes a page was torn out, often as a gift for a friend, but most of the sketchbooks are still complete. This sequence, for one of the colour wood-engravings illustrating G. de Nerval *The Queen of the Fishes*, 1895, the first Eragny Press Book, is profusely documented and shows his working processes clearly. This book was hand-printed by Lucien Pissarro himself who also hand-wrote the text for printed reproduction, and engraved the illustrations and border decorations. Later he had the use of the Vale typeface, before designing his own Brook typeface. In this sequence[1] the first drawing shows a younger girl than in the final image, set in a landscape, reaching into the water from the right. The idea is returned to in the sketchbook[2] with the model more carefully drawn, hair in a bun, now also reaching into the water from the left, still without a surrounding border. Two loose watercolour fragments on tracing paper – for the effect of the reverse printed image, and for transfer to wood-block – refine the image[3] which was then traced (though later photographed) onto the wood-blocks for engraving, one block for each colour. In this case there were four – the line block, red, blue and yellow. There are alternatives on loose sheets[4] in a border roundel. In addition, Lucien Pissarro used sketchbooks, to note anything he wished to remember; clearly he nearly always carried one with him, and book titles, addresses, train timetables or lists of people he was to see are sprinkled front and back and among the sketches, giving an extra biographical interest to their study.

Pissarro gift 1952

[1] Illustrations 77.1470
Sketchbook 1893 (21)
pp. 113, 115. 77.1472
final printed image
[2] pp.130, 131, 133
[3] 77.1470, 1471 not
illustrated
[4] 77.1743, 1744

Lucien Pissarro had begun drawing projects for the
illustration of children's books by 1884, in parallel to his
landscape studies. In conjunction with published illus-
trations for periodicals and the Anarchist press, they
were attempts to earn some much-needed money. None
found publishers. Camille Pissarro's own interest in
etching, and the naïf quality and simplicity of Lucien's
illustrations where the use of pure, clear colour under-
lines their joint interest in Japanese prints and the neo-
Impressionist theories, led naturally to wood-engraving
for Lucien, both as a suitable vehicle for expression and
a field in which father would not dominate son. Lucien
Pissarro began colour wood-engraving in 1889; this led
to his publication of *The First Portfolio* in 1893 – a group
of twelve loose wood-engravings in colour and in black
and white – and to the publication in 1894 of the joint
project album *Travaux des Champs* (Phase I). The obvi-
ous transition to books saw the first Eragny Press publi-
cation in 1895, a total of thirty-two books being
produced before war brought the press's closure in
1914. The technical mastery soon acquired by Lucien
Pissarro, whose concern was for a balance of decoration
and typeface on each printed page, found an outlet
among bibliophiles in England, Holland, America and
France. They were not financially profitable, especially
after his distributors, Ricketts and Shannon's Vale Press
(Hacon & Ricketts) ceased business in 1903. Lucien and
his wife Esther, who greatly helped him both with the
actual printing and the engraving of some of the orna-
ments, had little business sense. The books, of which a
complete set is in the Ashmolean, were in French or
English, usually short stories or poems by authors such
as Perrault, François Villon, Flaubert, Ronsard, Keats,
Coleridge or Emile Verhaeren, and were illustrated with
wood-engraving (often in colour), ornaments, borders,
decorative capitals, sometimes using gold. They were
produced in small editions on hand-made French
papers, usually on Lucien Pissarro's own press at home.
He also designed the end-papers and binding (which
was done profesionally), and, after the destruction of the
Vale typeface when the Vale Press closed, he designed
his own Brook typeface. This was first used in 1903 and
cast with money provided by Camille Pissarro.

JULES
LAFORGUE
MORALITES
LEGENDAI-
RES

31 Lucien Pissarro
Wood-blocks

Some of the wood-blocks engraved by Lucien Pissarro did not survive, five were given to other museums by Esther Pissarro: but the remainder, some 473, are in the Pissarro collection. They are mostly pearwood, a few boxwood; there are also some electro-plates. The majority were for use in the Eragny Press books, but there are also a few early ones engraved in the 1880s and 1890s as black and white illustrations for periodicals specialising in different forms of reproduction such as *La Revue Illustrée* and *La Vie Moderne*, or *L'Estampe Originale* in Paris, the *Dial* in London, and *Van Nu en Straks* in Brussels. The *Almanach du Père Peinard* also used Lucien Pissarro's wood-engraving, but mostly his illustrations for the anarchist press and others were simply reproduced drawings. For engraving, Lucien Pissarro began having his drawings photographed onto the wood-blocks from 1891; the alternative method, to trace them on, especially when four or five colour separation blocks were to be used, was a very lengthy process. They were then engraved by him – those illustrated here show the line and three of the four colours blocks (pink, red and blue) for 'Les Sarcleuses' (1893) from Camille Pissarro's drawing for the *Travaux des Champs* album (Phase I). They allow the complicated engraving process to be followed, each colour demanding a surface to be cut in relief so that in its printing, a separate run for each colour, each exactly fitted with the line and other colour blocks without overlap. The crosses which appear op-posite outside the engraved image on the block surfaces were for lining-up on the printing press. The later blocks even omitted the line block, the image being entirely shaped with the colour areas in chiaroscuro. The printing had to be done on slightly dampened paper: first the blocks and decorative elements, the text being added in a final printing. Lucien Pissarro normally produced a small number of each Eragny Press title on vellum as well, for specialist collectors.

Pissarro gift 1952
Illustration: line and pink, red and blue colour wood-blocks for 'Les Sarcleuses'

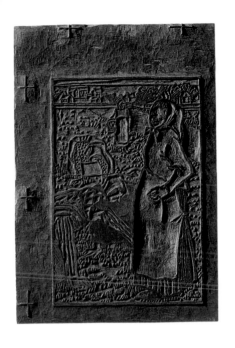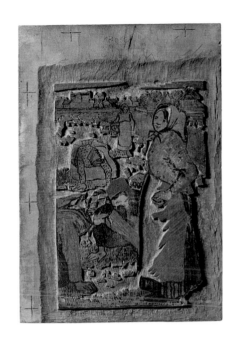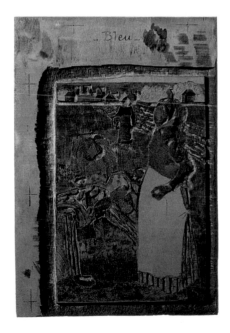

Correspondence

Like his father, Lucien Pissarro kept almost all the letters he received, though only some, including most of those from his parents, have survived prior to his final move to The Brook in 1902. This huge mass, which in Lucien's case covers every aspect of his life, is now divided for study into 'Selected Letters' – those from artists, or writers – and 'General correspondence'. The latter section comprises letters from less famous friends, Eragny Press material, dealers, museums, accounts. Family letters form a separate section. Some of the sequences number over 500 letters and cover the entire span of the friendship in question, sometimes with copies of Lucien's own replies. The wide range of his correspondents make the archive most important not only for art historians but also for biographers of a large selection of figures in the artistic and literary worlds of London, Paris and Brussels in the late nineteenth and early twentieth centuries. A good part of the material remains unpublished.

So much of the writer's character is apparent from the handwriting that the reader's enjoyment of these letters gains an extra dimension. The archive includes three amateur attempts at graphology by Gauguin from letters lent to him in 1884 by Camille Pissarro. The choice of letterhead, ink, paper or scrap also helps to bring the authors alive. Monet's difficult writing demonstrates his well-known long eye-sight. Gaugin has an orderly, delicate hand. Signac's is vivacious, Félix Fénéon's logical and positive. The Belgian Henry Van de Velde designed his own headings and used different coloured inks, often in one letter. Octave Mirbeau is almost illegible, Théodore Duret's writing is vigorous, the anarchist Jean Grave's almost conventional, Sickert's fussy. The Pissarro archive also includes papers relating to the division of Camille and Julie Pissarro's estates, photographs, exhibition catalogues, reviews, inscribed books from friends such as Emile Verhaeren, Jean Grave, Gustave Geoffroy or Auguste Hamon, and runs of various magazines and periodicals now very rare, including some for the Anarchist press.

Pissarro gift, from 1952
Illustration: Claude Monet to Lucien 24 February 1904
Paul Signac to Lucien Pissarro (4 January 1890 postmark)
Félix Fénéon to Lucien Pissarro (4 May 1895 postmark)
Henry Van de Velde to Lucien Pissarro 14 December 1894

24 fév: 1904

Mon cher Lucien

[handwritten letter, largely illegible]

Cher ami Lucien

[handwritten letter, largely illegible]

La revue blanche
1, Rue Laffitte

Paris, le 189

Cher ami,

[handwritten letter, largely illegible]

c'Arts d'Industrie et d'Ornementation

65, Dieweg, Uccle-Calevoet.

[handwritten letter, largely illegible]

M. M. Stéphane Mallarmé
Henri de Régnier
Francis Vielé-Griffin
Charles van Lerberghe
May Los Baues
Maurice Maeterlinck
J. H. Rosny
Adolphe Retté
Félix Fénéon
Maurice Barrès
Georges Eekhoud
Eugène Demolder

33 Georges, Félix, Ludovic-Rodolphe and
Paul-Emile Pissarro

Camille Pissarro's younger sons were all artists, and are represented in this collection both with original works and with series of letters. The exception is Georges (Manzana) (1871–1961), as his difficult character, doubtless enhanced by the early deaths of his first wife and his closest brother, led to a complete break with Lucien. Consequently, there were fewer letters or examples of his work. In youth he was a gifted and original artist; but the need to earn money perhaps partly explains later compromises to produce what was frankly commercial, together with a tendency to attribute dubious works to the hand of his father. Félix (pseudonym Jean Roch, 1874–97) showed great promise and, in his wood-engraving, both talent and fantasy for which his early death allowed no development. Ludovic-Rodo (1878–1952) was a competent artist, with a gift for caricature – again also doing wood-engraving. His sardonic character and ability to express himself make his letters, some 1400 of them, a joy to read. From 1930 he worked on the catalogue of his father's oil paintings (P&V), published in 1939.

Paul-Emile (Paulémile 1884–1972) had the least time working with his father, who died when Paul-Emile was nineteen. From his letters, his character appears as delightful, and he made a successful career as a landscape painter, eventually under contract to the W. Findlay Gallery, New York.

Illustration: Ludovic-Rodo Pissarro: *Woman in feathered hat*
Pastel 63.5 × 46cm, 77.1583

74

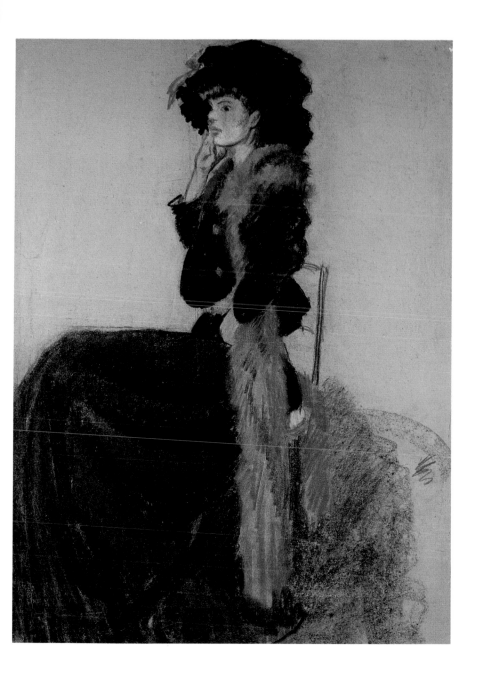

34 Orovida Pissarro
The Archer's Return 1931

Orovida (1893–1968), the only child of Lucien and Esther Pissarro, was a prolific etcher and painter whose highly individual manner was strongly influenced by Oriental art. Born Orovida Camille Pissarro at Epping, Essex, she was raised at The Brook in Hammersmith and spent most of her adult life in London. She travelled widely in Europe, but never visited the Far East; such exotic paintings as *The Archer's Return* (1931) derive in part from a tireless study of Oriental art and culture, but ultimately are imaginary visions created in the artist's mind. Orovida's most constant and important teacher was her father, and his influence is most evident in such early Impressionist paintings as the *Self-Portrait* (1913) in the Pissarro Collection. Orovida turned away from the Impressionist tradition in order to assert an individual style and, signing her works with her first name only, sought to distance herself from the Pissarro legacy. A Japanese friend, Tatuo Takayama, taught her to paint with delicate washes on silk, as exemplified in the exquisite screen of 1924–25, *Boy and Cat*. Orovida came to prefer the matt effect of bodycolour and tempera and began painting in broad, flat expanses of colour. From 1925 until 1932, she painted almost exclusively on silk, stretched across large panels and bordered with Oriental brocade. In 1931, with *The Archer's Return* she introduced linen, a stronger foundation for the heavier tempera mixtures. A change occurred in the 1940s, when she began to embrace contemporary subjects and to paint more naturalistically. Practical concerns may have prompted these shifts: the eggs for her egg tempera mixture became prohibitively expensive during the War, and manufactured tempera by the main producer, Rowney's, was temporarily unavailable. Lucienn Pissarro's death in 1944 may have freed her to some extent from fear of comparison with her father. The Pissarro Collection holds several examples of Orovida's later paintings in oil, including her *Self-Portrait* (1953), along with several early decorative paintings. The Collection is the principal centre for studying the work of Orovida and includes nine paintings, numerous wood-engravings, drawings, a nearly complete set of etchings, her own manuscript catalogue of paintings and etchings as well as hundreds of letters.

Tempera on linen 112 × 160cm, signed and dated 1.1. (on camel's saddle)
Ashmolean Museum, Pissarro bequest 1968. A1050a

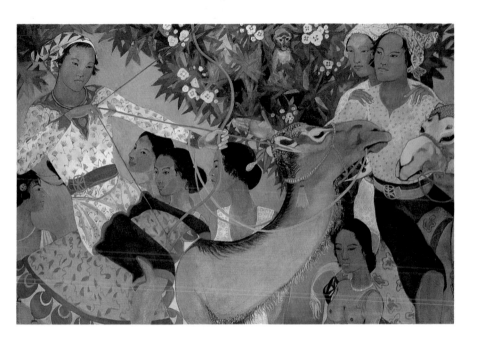

35 Orovida Pissarro
Tiger Crouching 1914

Orovida began working as a print-maker around 1908 and turned to etching around 1913. She was largely self-taught and highly experimental, and continued etching throughout her career, progressing through several distinct stylistic and technical phases. The first etchings she catalogued were completed in Camille Pissarro's studio at Eragny, during a 1914 visit with her uncle Paul-Émile. Perhaps Pissarro's unorthodox techniques encouraged her to incorporate accidents with acid into her prints, to use sandpaper and various experimental forms of aquatint, and to sign trial and working proofs. *Tiger Crouching* (1914) is one of the three known prints completed solely in aquatint, and the only print employing two registered plates in the manner of chiaroscuro wood-block printing. The first plate set out the design in thick, dark outline in a manner recalling Japanese wood-block prints. The second plate added tone, and experimen-tation with various combinations of black, brown and vermilion inks created striking effects. An edition of twenty prints of *Tiger Crouching* marks the start of collaboration with the professional printer David Strang. Orovida owned her own press and printed many proofs herself, but she also relied heavily on Strang and other printers. Wild animals, in particular tigers, were her passion and these were studied at the London Zoo. In 1922, the French Société de l'Estampe Nouvelle commissioned two prints with the intention of publishing a *Jungle Book* illustrated by Orovida but the project was never completed. In 1916, while studying lithography under F. E. Jackson at the Central School of Art, Orovida invented her own aquatint method employing lithographic crayon rubbed directly onto the etching plate. This produced a grainy, variable tone which she combined with dust-box and resin grain aquatints for a range of tonal effects. From 1922 onwards, she often used etchings as preliminary notes for her paintings and gradually became less experimental. In the 1930s, she settled on an efficient single-state line-etching technique which allowed a print to be rapidly and efficiently executed. Orovida was active in a number of print clubs including the Chicago Society of Etchers, the Print Club of Cleveland and the Société des Peintres-Graveurs et Lithographes Indépendants, called 'Le Trait'. Her etchings were exhibited around the world and today they figure in prominent collections in England, France and America.

Aquatint, two registered zinc plates (brown on brown)

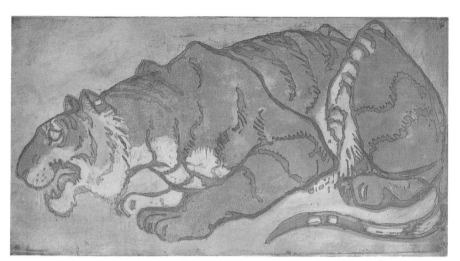

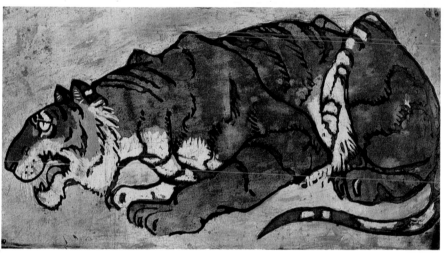

Bibliography

Apollo *Special Pissarro issue,* November 1992.

Arts Council *Camille Pissarro.*1980-81 Exhibition catalogue.

Bailly-Herzberg, J. *Correspondance de Camille Pissarro,* Paris 1980-91 5 vols.

Bensusan-Butt, J. *The Eragny Press 1894-1914,* Colchester 1973 (privately printed).

Brettell, R. & Lloyd, C. *A Catalogue of the Drawings by Camille Pissarro in the Ashmolean Museum, Oxford,* Oxford 1980.

Brettell, R. & Pissarro, J. *Pissarro and Pontoise: the painter in a landscape,* Yale 1990.

―――― *The Impressionist and the City: Pissarro's Series Paintings,* Yale 1992.

Delteil, Loys *Le Peintre-Graveur Illustré* Vol. 17 – *Camille Pissarro, Alfred Sisley, Auguste Renoir,* Paris 1923.

Erickson, K. *Orovida Pissarro: Painter and Print maker; with a catalogue of paintings.* 1992 Thesis, University of Oxford.

Fern, A. & Urbanelli, L. Revised edition of *The Wood-engravings of Lucien Pissarro,* 1960 Thesis, University of Chicago. Forthcoming.

Lant, A *Pissarro, Degas and Cassatt as print-makers in 1880.* 1979 Thesis, University of Leeds.

Lloyd, C. *Camille Pissarro,* Geneva 1981.

―――― *Studies on Camille Pissarro,* London 1986 (Editor).

Lloyd, C. & Thomson, R. *Impressionist Drawings from British Public and Private Collections,* Arts Council exhibition catalogue 1986.

Pellé, M.J. *Les Eventails de Camille Pissarro,* Paris 1990.

Pissarro, J. *Pissarro,* New York 1993.

Pissarro, L.-R. & Venturi, L. *Camille Pissarro. Son art – son oeuvre,* Paris 1939. 2 vols.

Shikes, E.E. & Harper, P. *Pissarro: His life and work,* New York 1980.

Thomson, R. *Camille Pissarro: Impressionism, landscape and rural labour.* South Bank Centre exhibition catalogue 1990.

Thorold, A. *A Catalogue of the oil paintings of Lucien Pissarro,* London 1983.

―――― *The Letters of Lucien to Camille Pissarro, 1883–1903,* Cambridge 1993.